WHAT'S INS

This beautiful coloring book is not only a way to decompress from the stress of this world, it's also a form of positive action. Every copy sold makes a difference because a portion of the profits will be donated to nonprofit organizations that empower women.

Take a look at a few of the 38 fabulous designs inside, just waiting for you to color them:

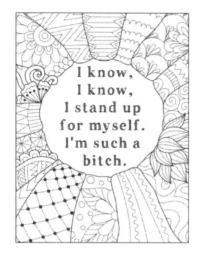

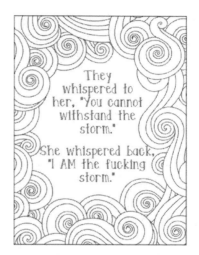

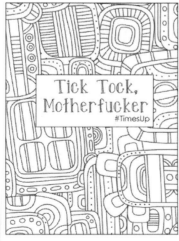

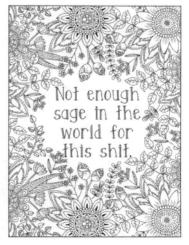

LET'S GET COLORING!

The Totally Inappropriate Coloring Books:

YOU'RE THE SHIT
YOU'RE TOTALLY BADASS
YOU ARE ONE BAMF
F♥CK CANCER*
F♥CK THE PATRIARCHY**

*(a portion of the proceeds donated to research dedicated to finding a cure for cancer)

**(a portion of the proceeds donated to nonprofit organizations that empower women)

The Totally Appropriate Coloring Books:

SMASH THE PATRIARCHY**

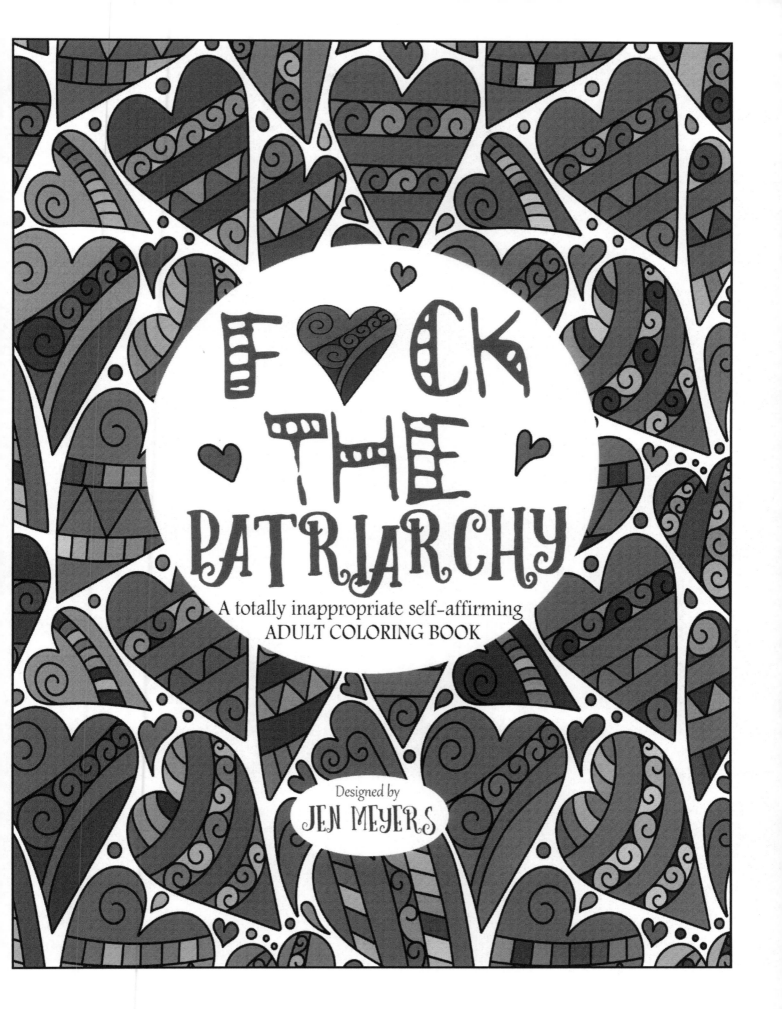

Please Note: This books contains adult language
and is not intended for children.

Published in October 2018 by Turning Leaves Press, Inc.

Artwork © Andriy Lipkan, Somjai Jaithieng, Irinakrivoruchko, Julia Snegireva, Maria
Skorchenko, Anastasiia Strelchenko, Alexandra Norina, Nataliebakunina, Galyna
Novykova, Iuliia Skorupych, Roman522, Lenkisart, Mary Deneko, Kchungtw, Helen
Yepifanova, Tatiana Gorohova, Nontachai Hengtragool, Vera Volodkina, Lilipom10 ::
www.dreamstime.com

ISBN 9781726744430

WELCOME!

Let me get right to the point of this book: we need to smash the patriarchy, we need to burn it to the ground. Our society is failing its citizens—both female and male—with the blatant double standards for women and men, girls and boys.

Dress codes in schools are all about shaming girls for their bodies and sending the message that girls' bodies are nothing more than sexual objects, that boys cannot control themselves, and that girls are responsible for boys' actions. Those boys grow into men who feel entitled to women's bodies, who don't believe women to be as valuable as men, and who perpetuate this horrid system. And even though it is men who sexually harass and assault women, it's the women who are continually blamed for it: "What were you wearing? What did you say/do to him? Were you leading him on? Had you been drinking?" And if we're not blamed, then we are also not believed. "How can you be sure it was him? Do you have any idea what this will do to his future/career/family? Are you trying to destroy him? Is this just spite?"

But let me ask you this: when was the last time a man was ridiculed for coming forward with sexual assault allegations against a Catholic priest after 10, 25, or 35 years? Is he ever not believed? Is he ever asked what he was wearing at the time or what he did to bring it on himself? Is the validity of his memories ever called into question? No. Not once. And it shouldn't be. But neither should it be for women.

Our society MUST change. And it must. Change. Now.

I hope this book inspires you to be heard, be seen, and be believed...because you DO matter. Keep fighting to change this world for the better. Let the designs and words fuel your fire as you come back to your truth within the pages of this coloring book, and discover your own power to change the world—yours and the larger one around you.

After all, it takes every single one of us. Let's get smashing.

In solidarity,

JEN

P.S. In purchasing this book, you're already helping to make a difference—a portion of the profits from the sale of this book will be donated to not-for-profit organizations that empower women. Thank you for your help!

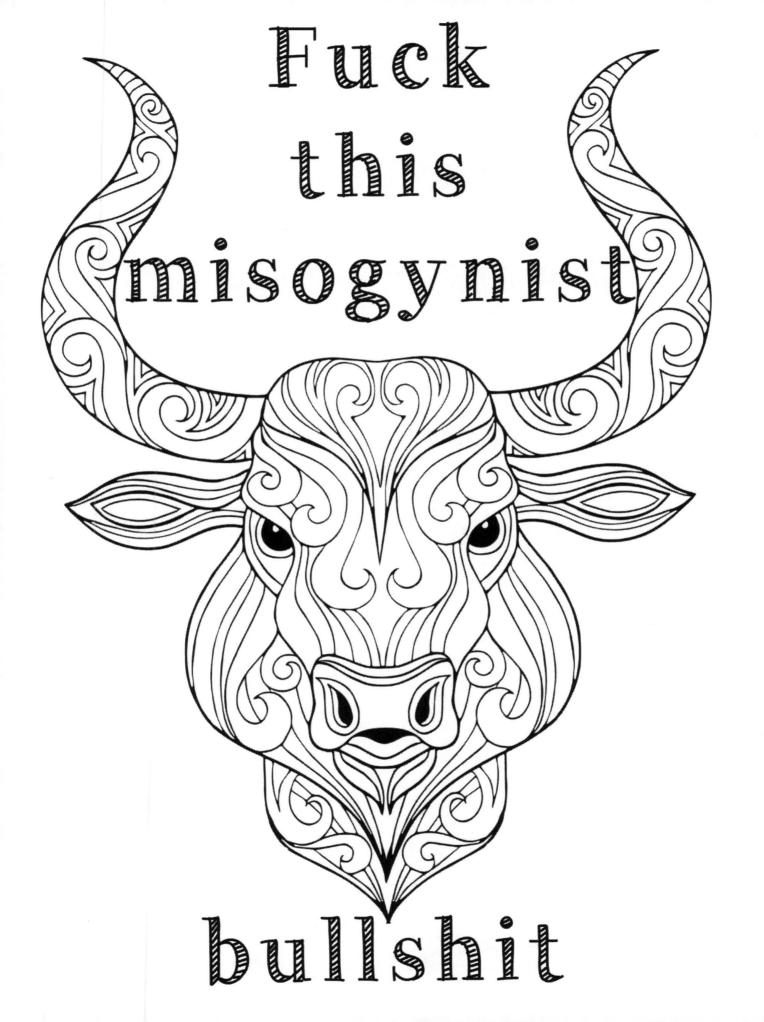

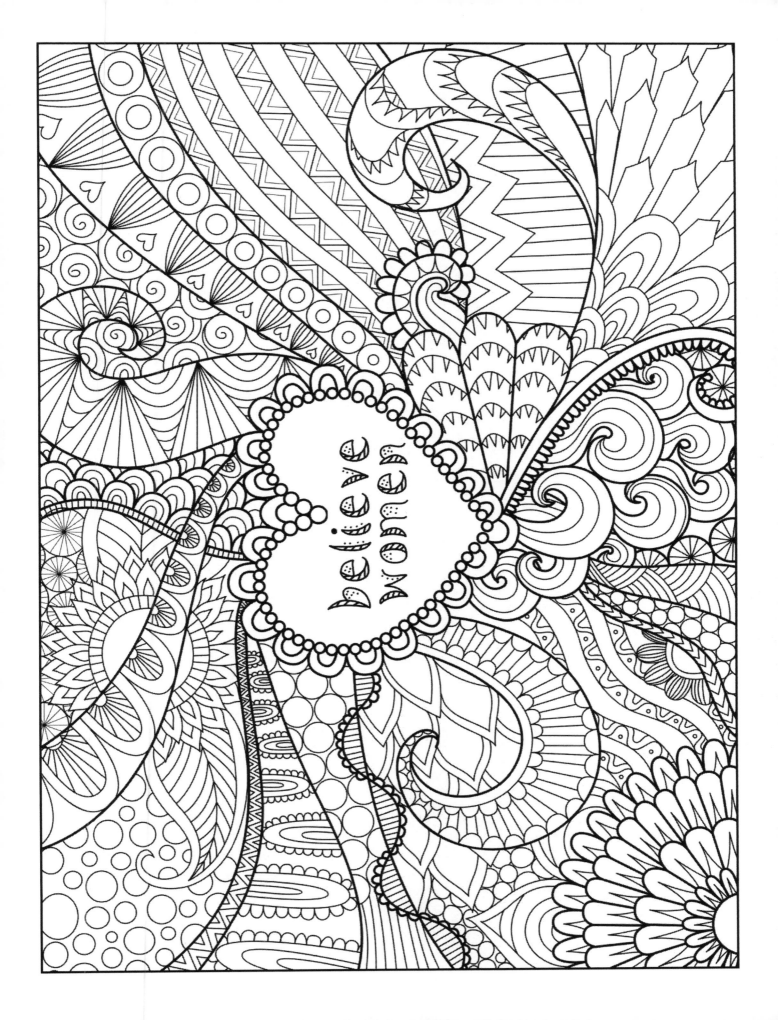

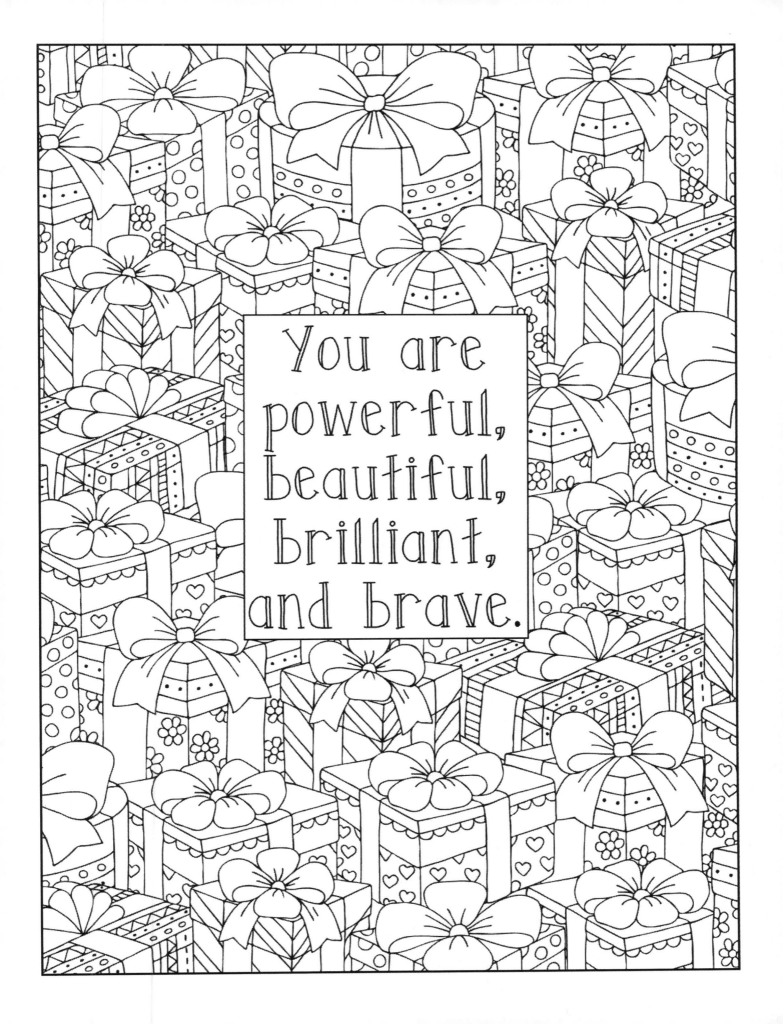

You are powerful, beautiful, brilliant, and brave.

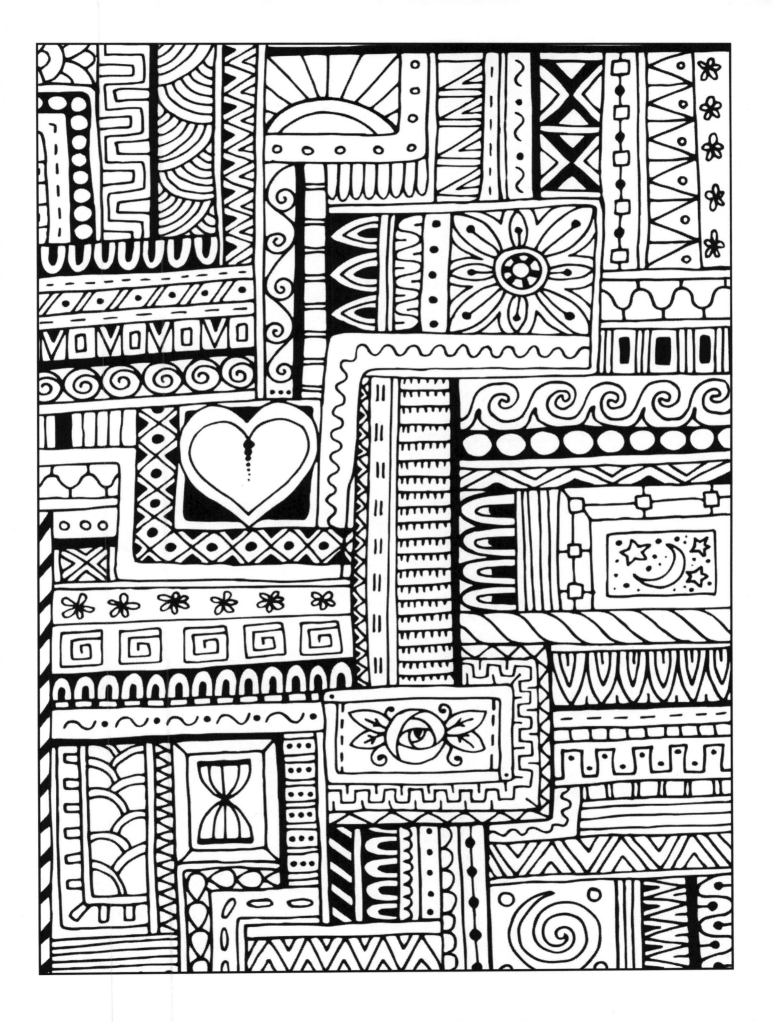

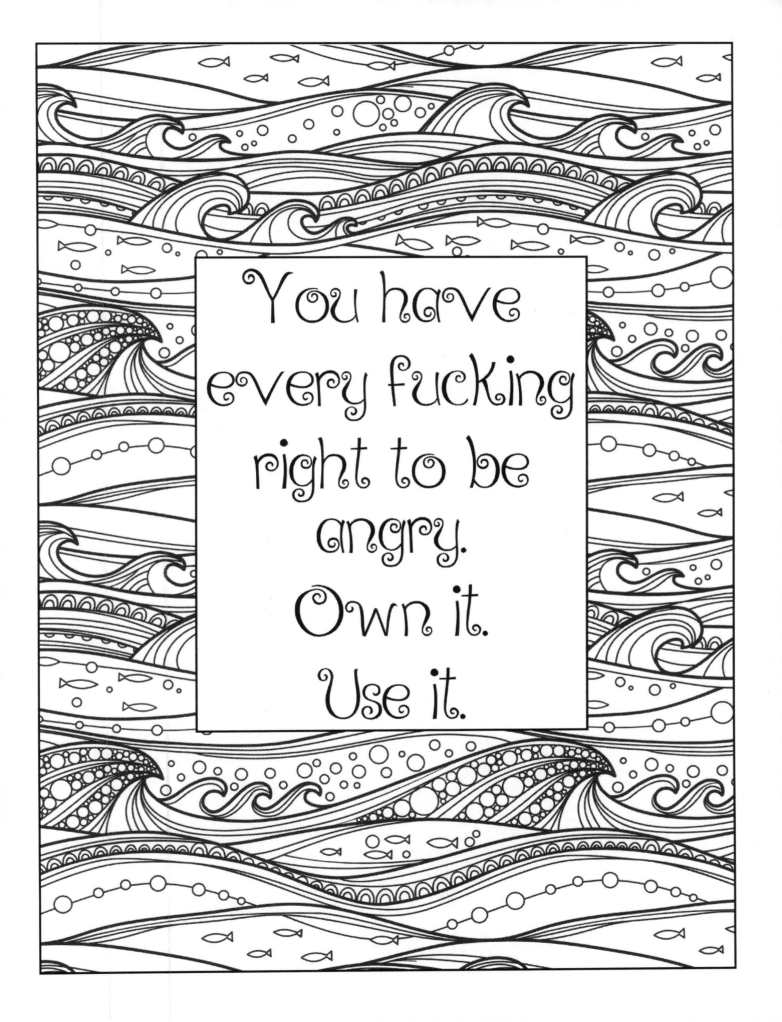

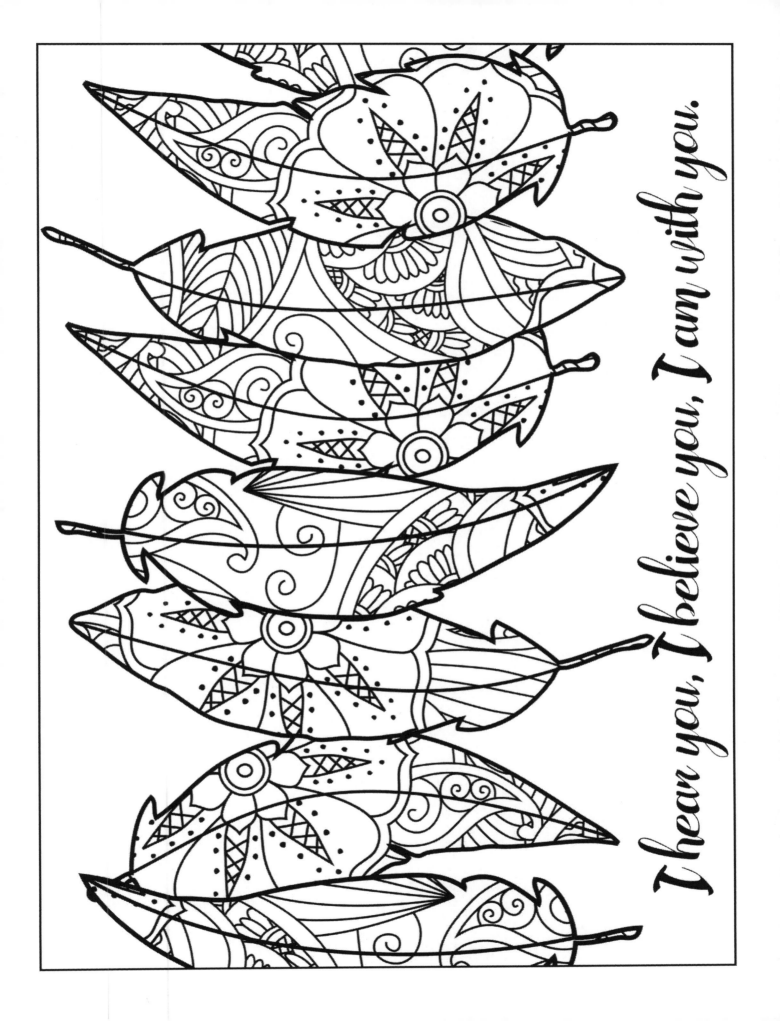

I hear you, I believe you, I am with you.

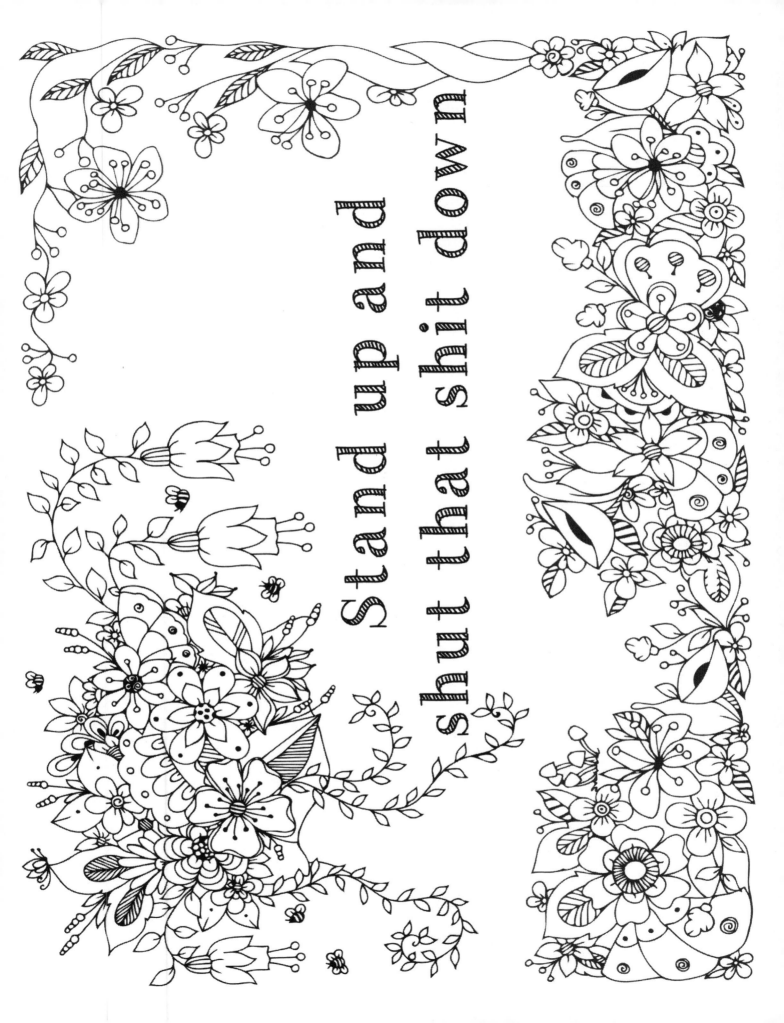

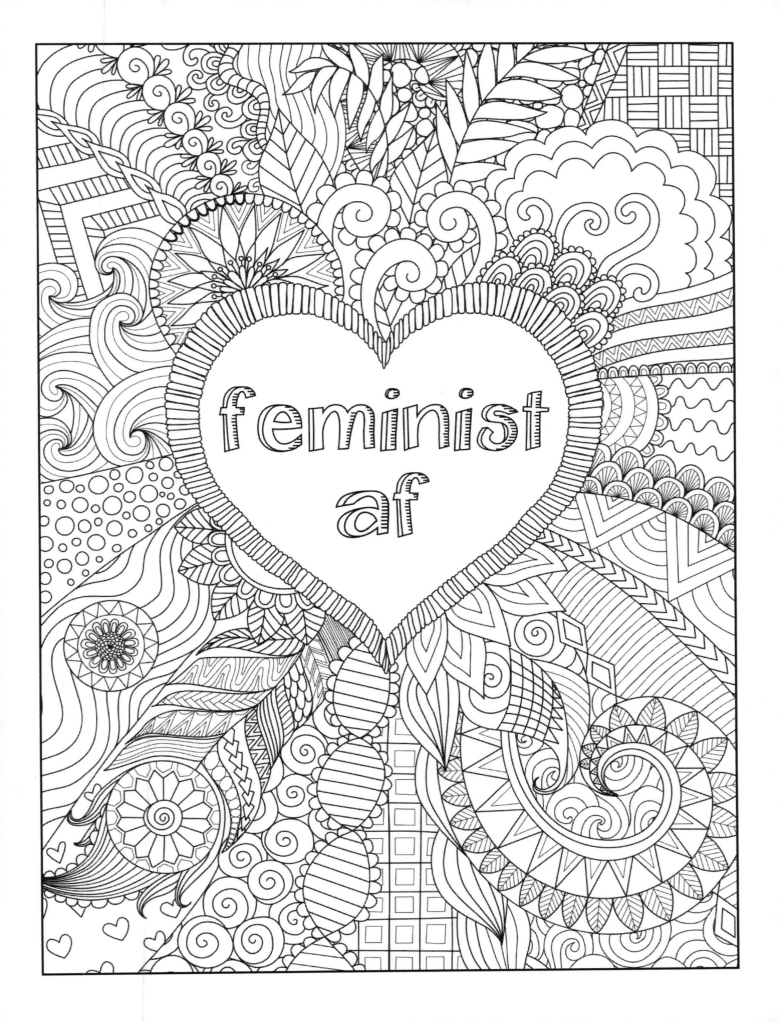

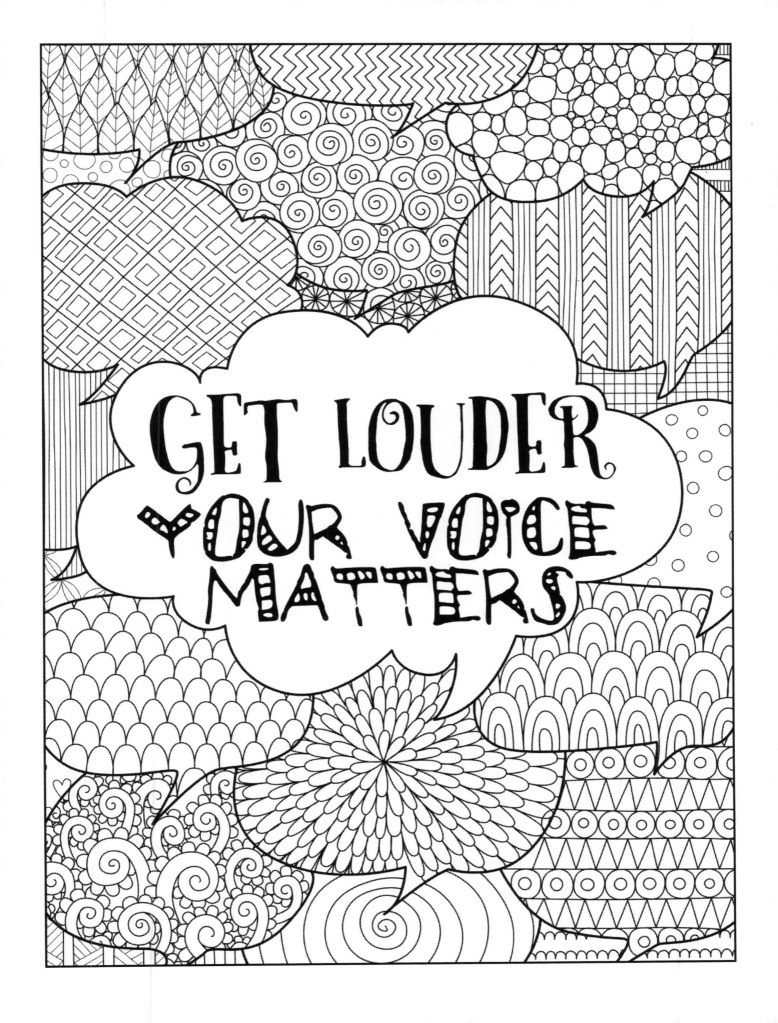

Roar like your fucking life

depends on it
(it might)

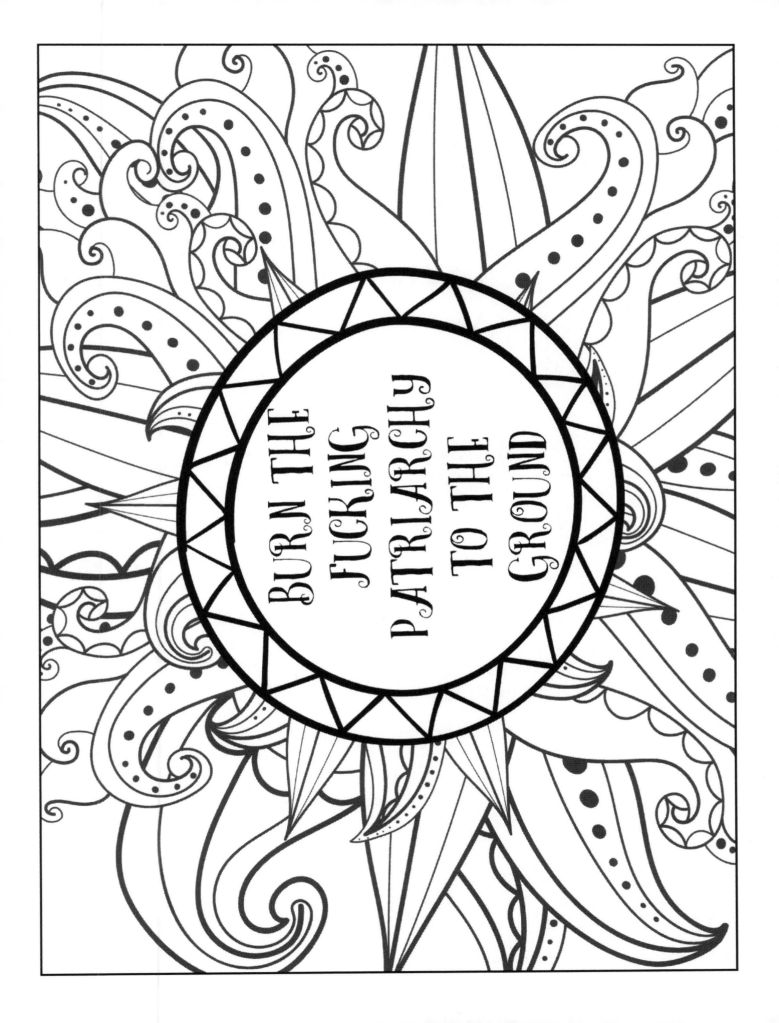

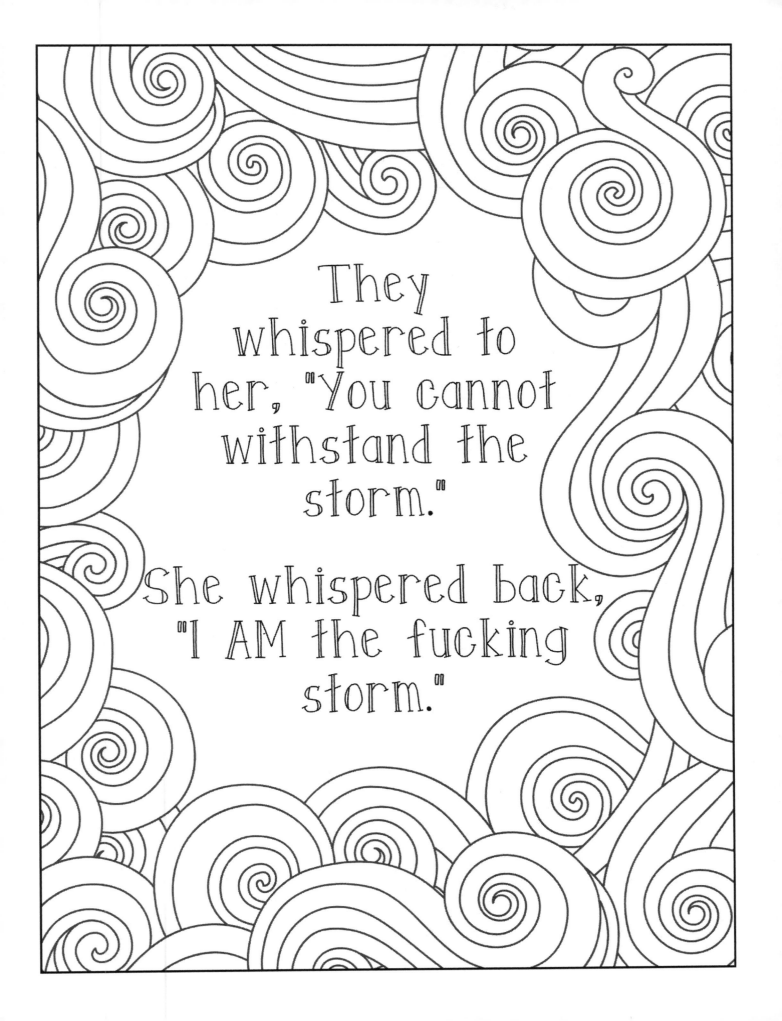

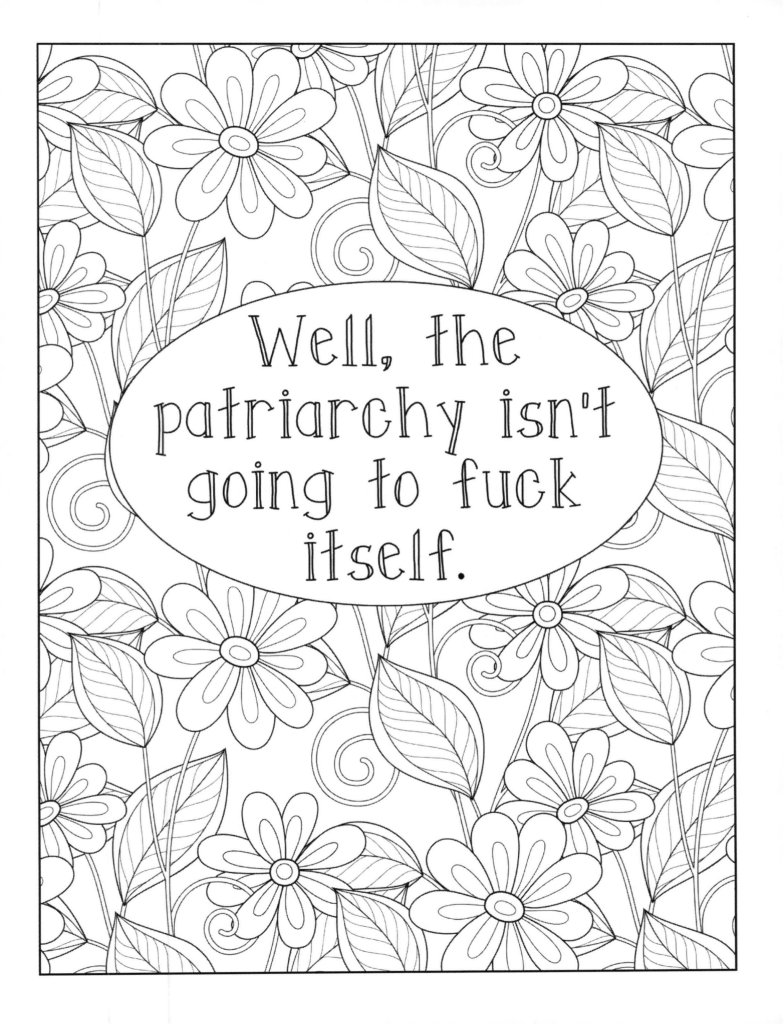

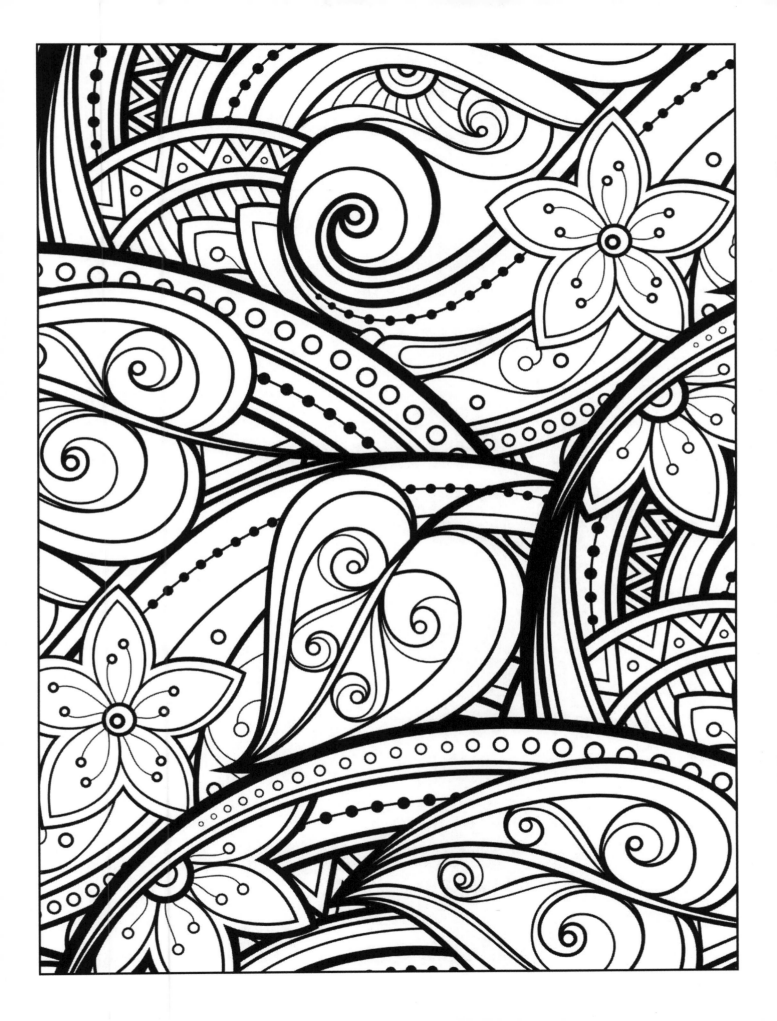

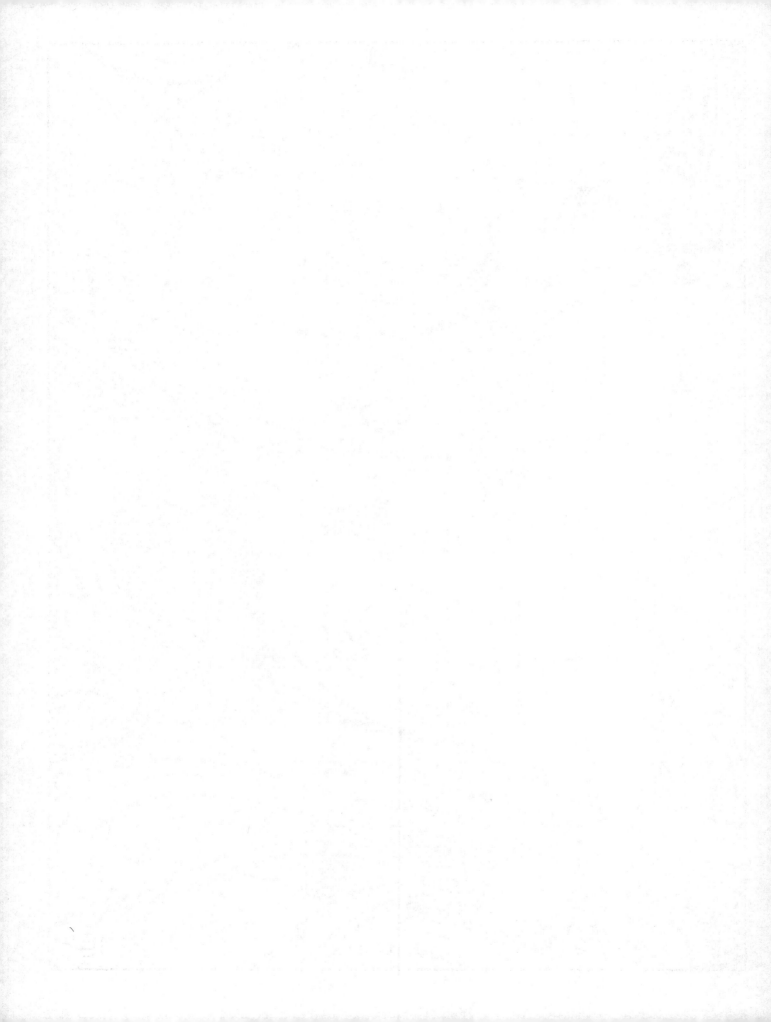

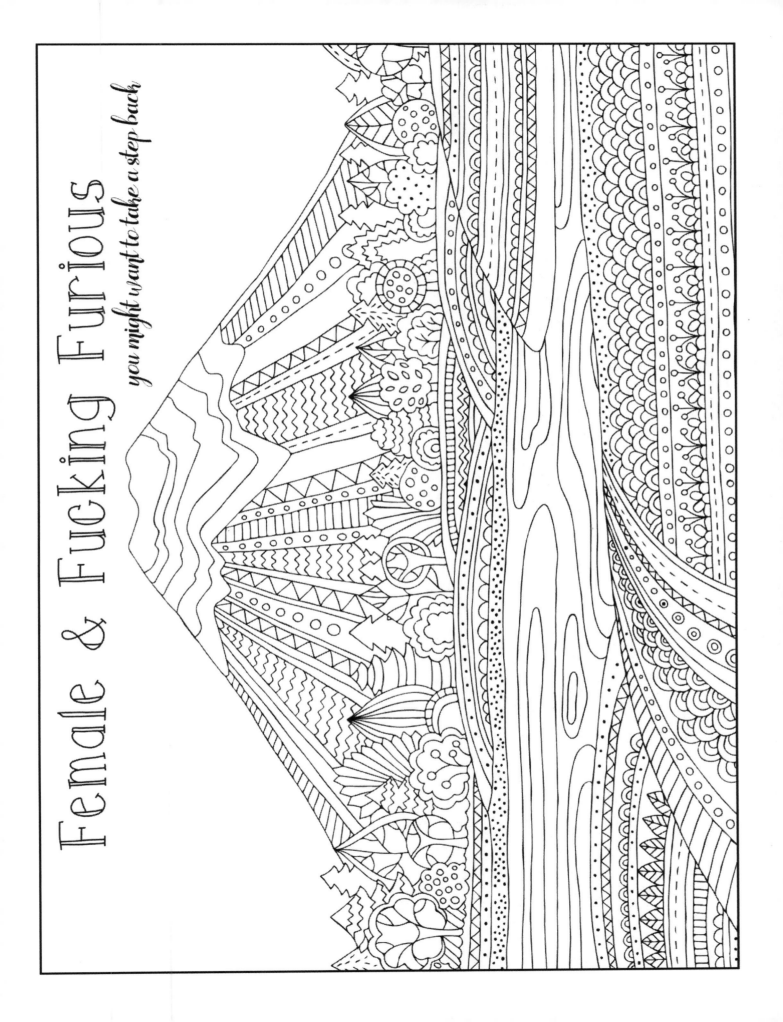

Female & Fucking Furious

you might want to take a step back

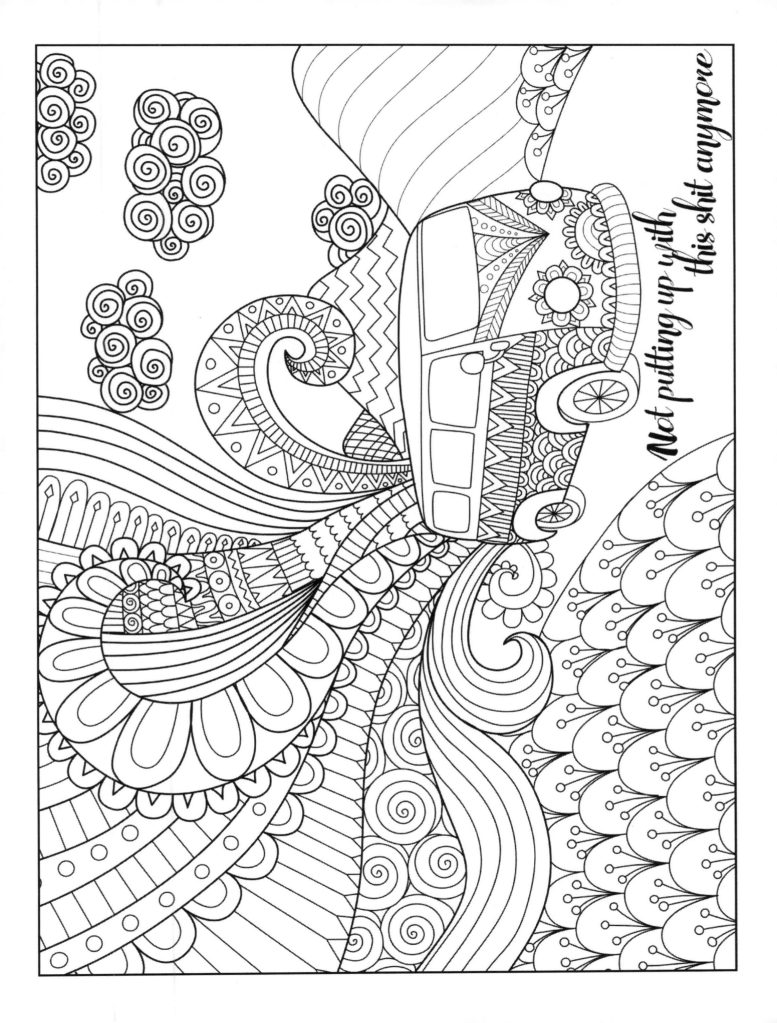

Nevertheless,

She Persisted.

the future is

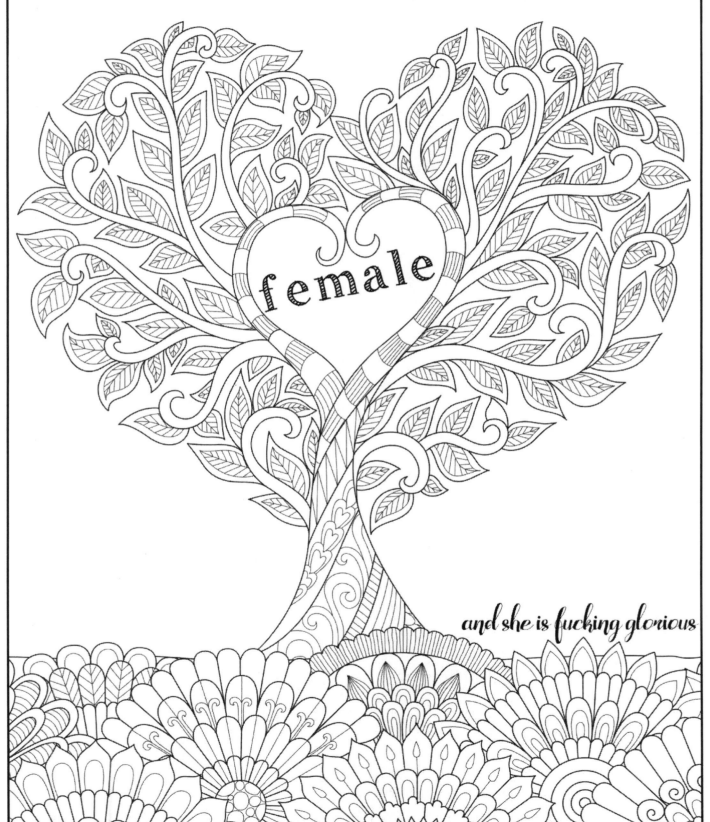

female

and she is fucking glorious

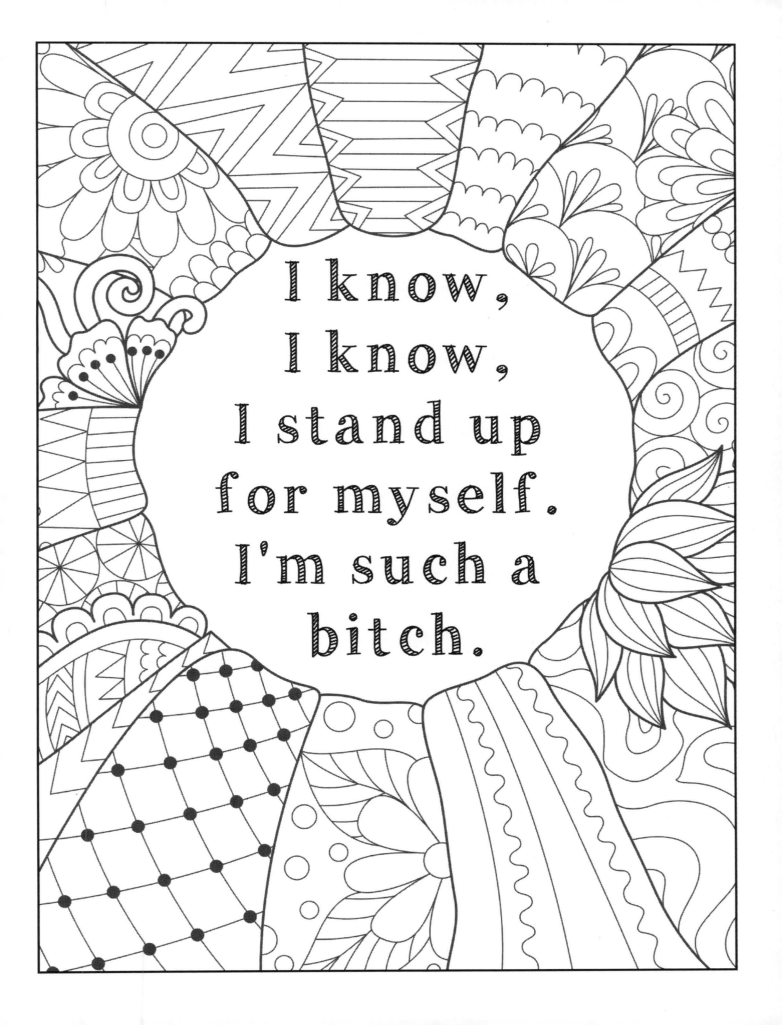

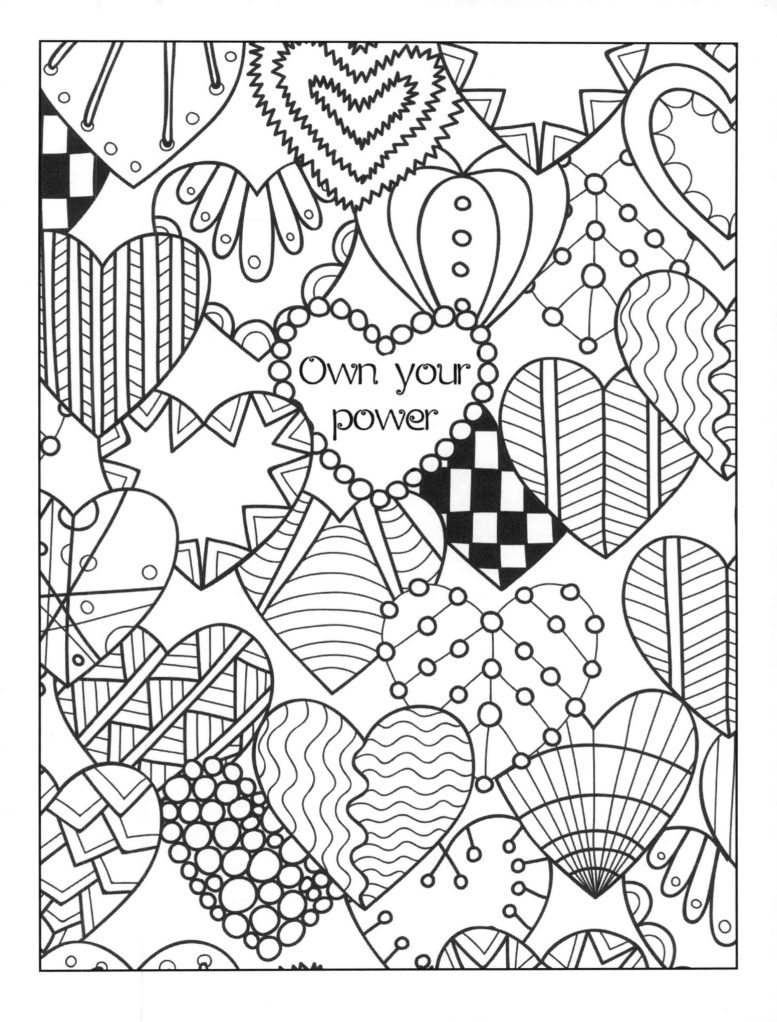

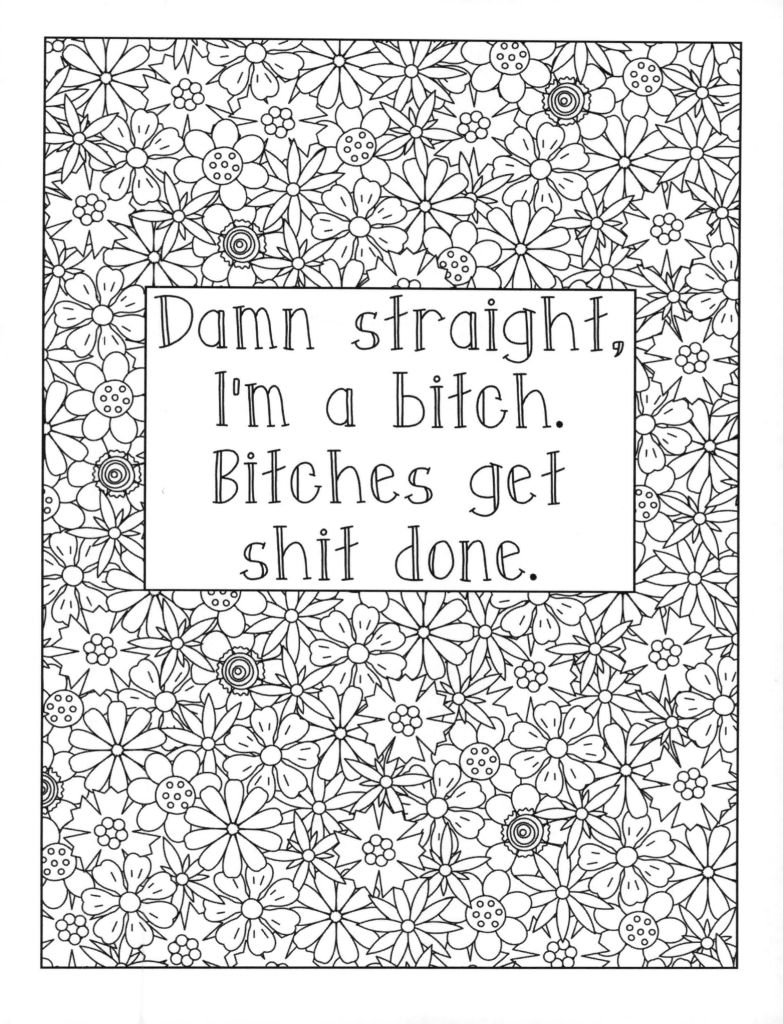

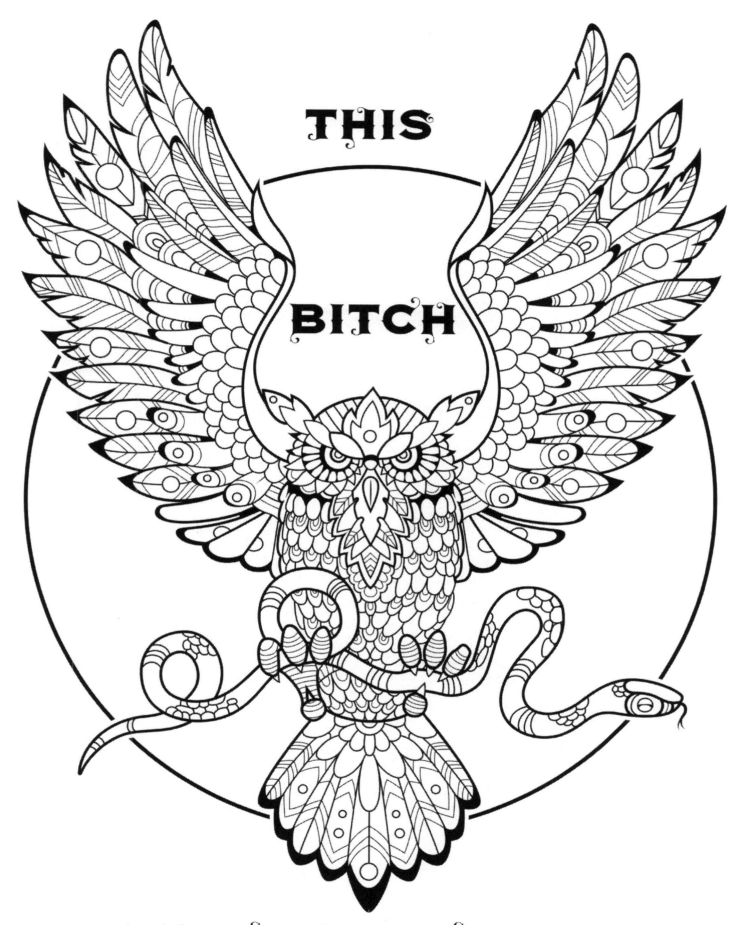

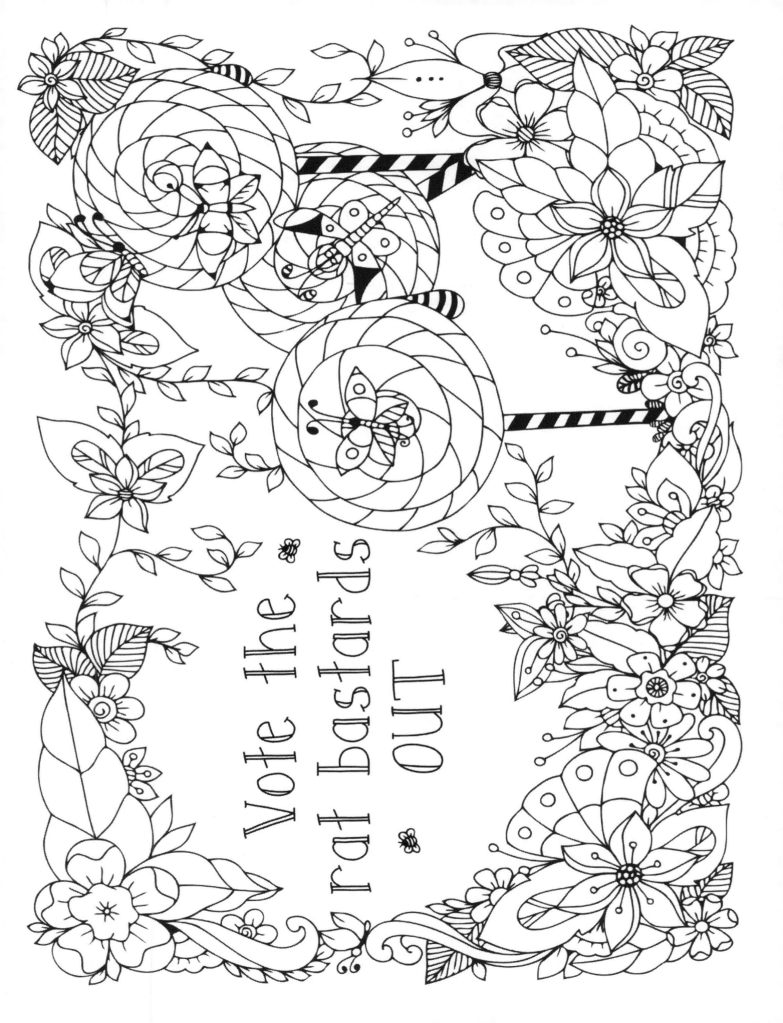

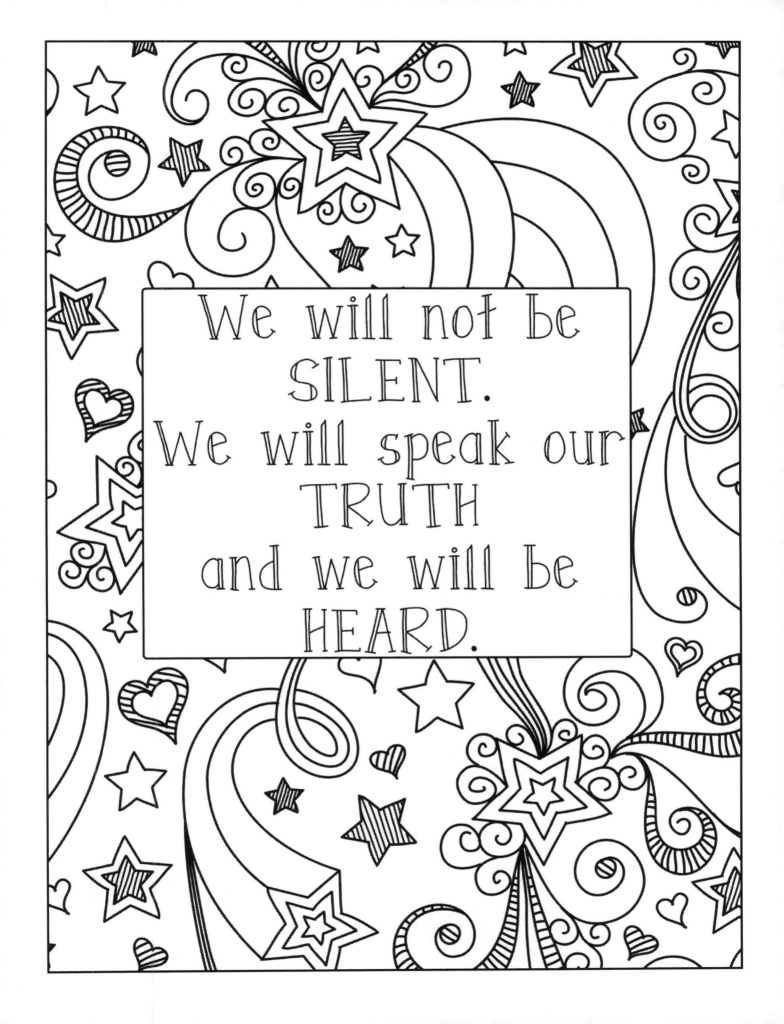

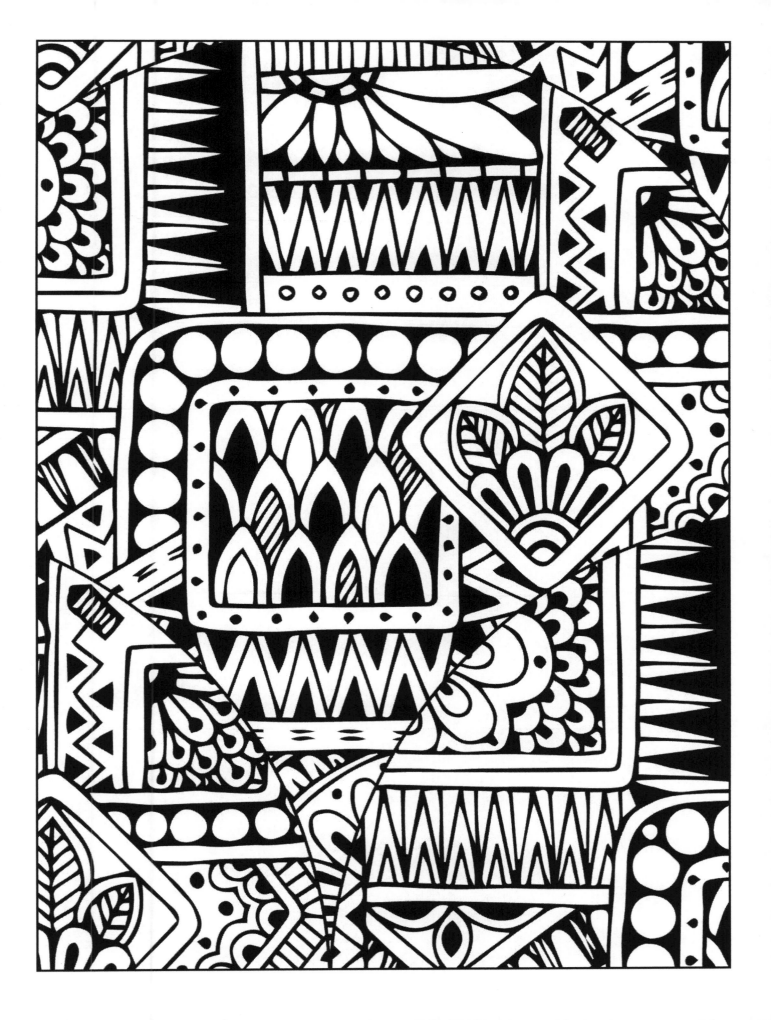

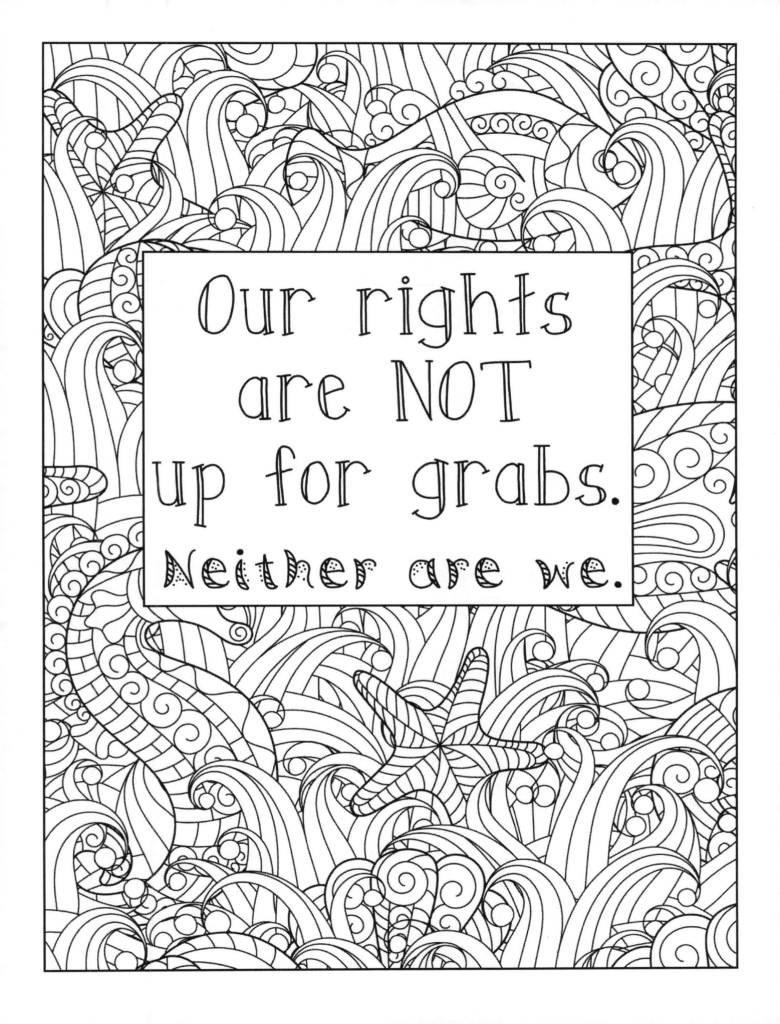

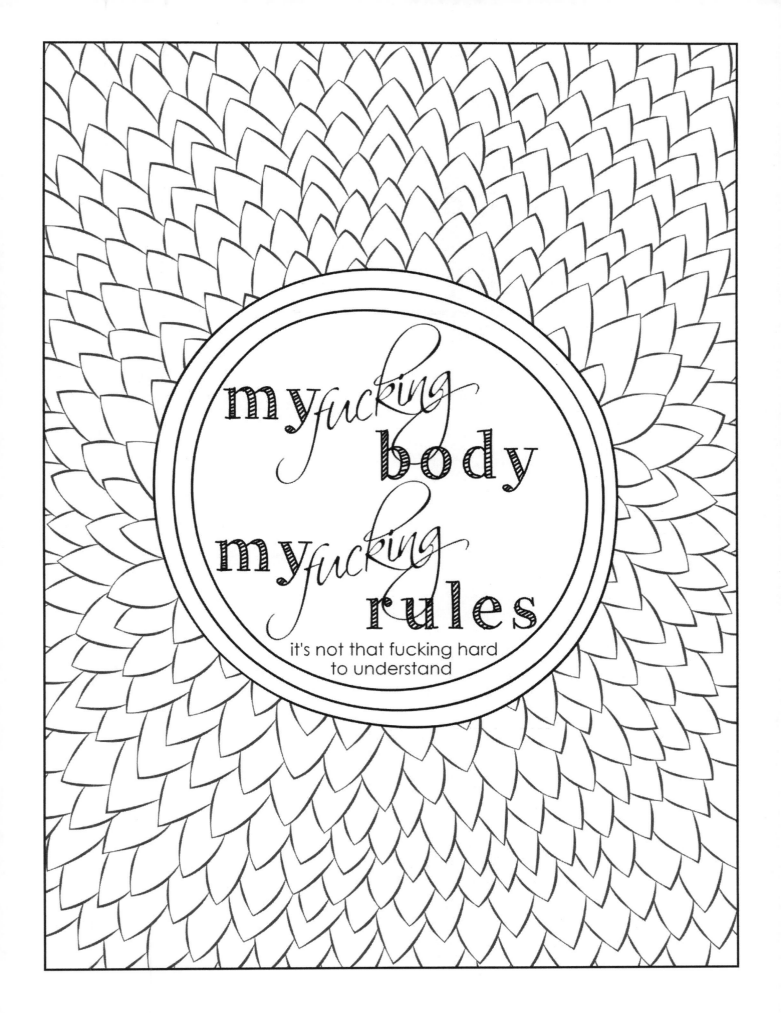

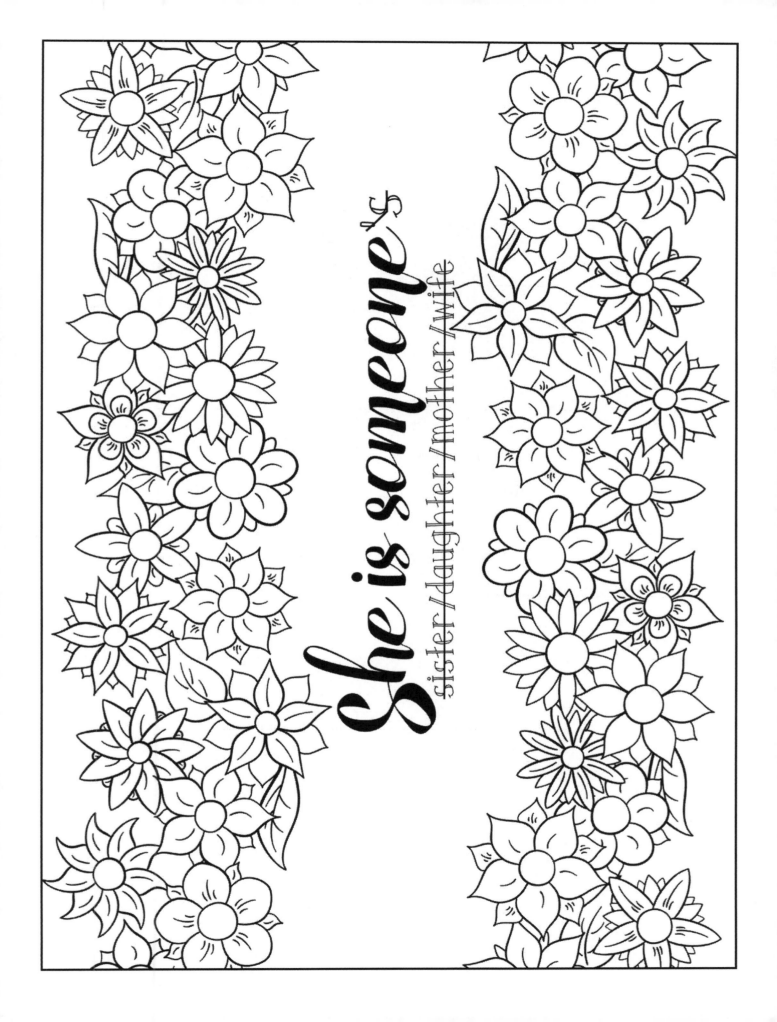

She is someone's
sister/daughter/mother/wife

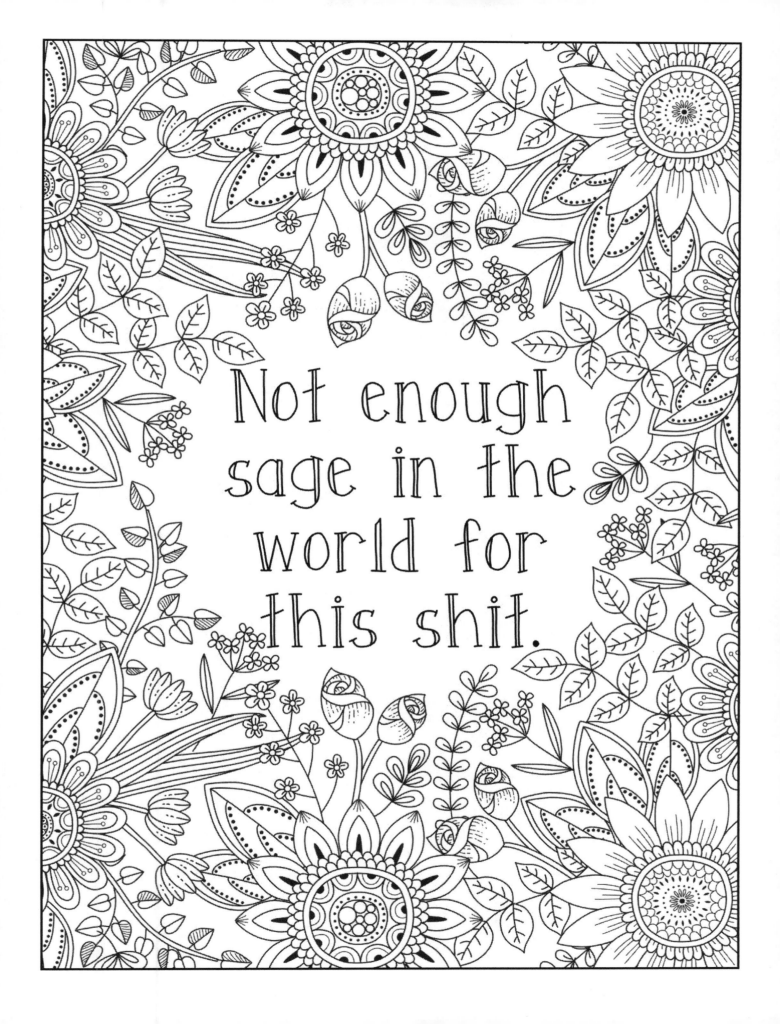

Not enough sage in the world for this shit.

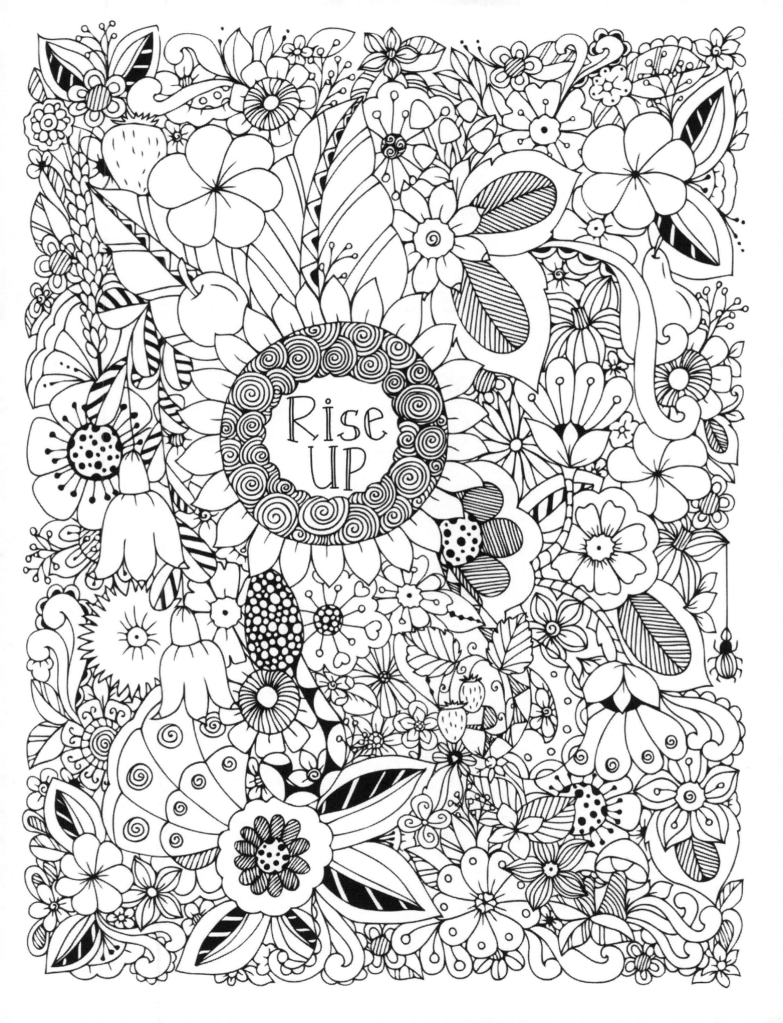

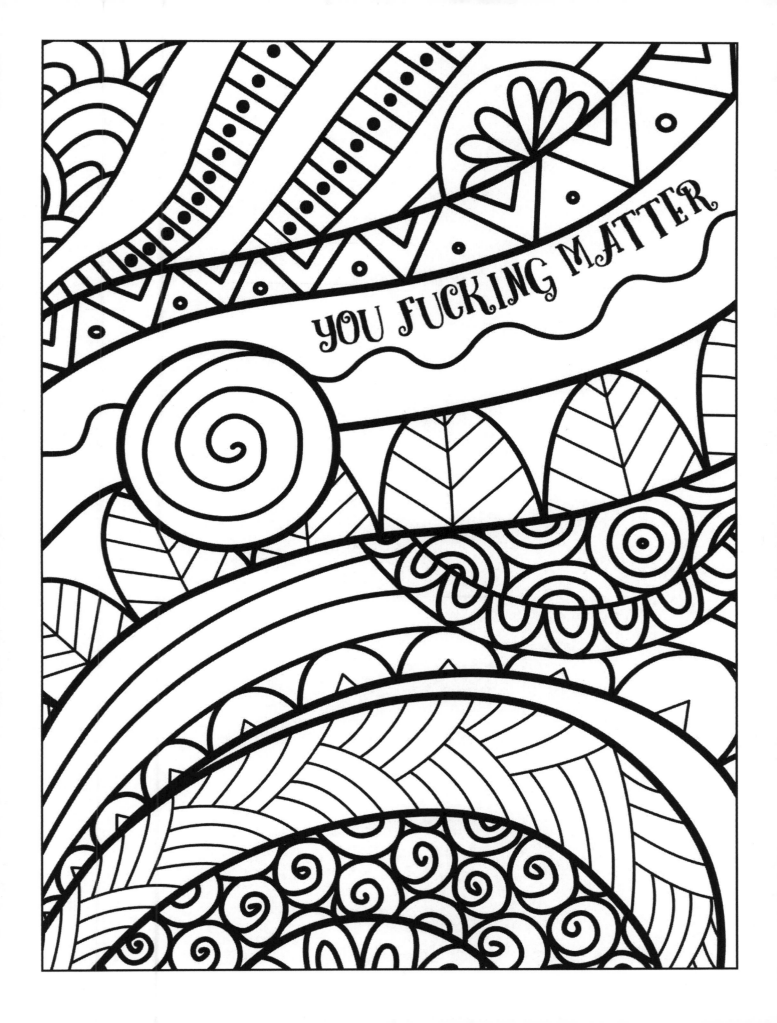

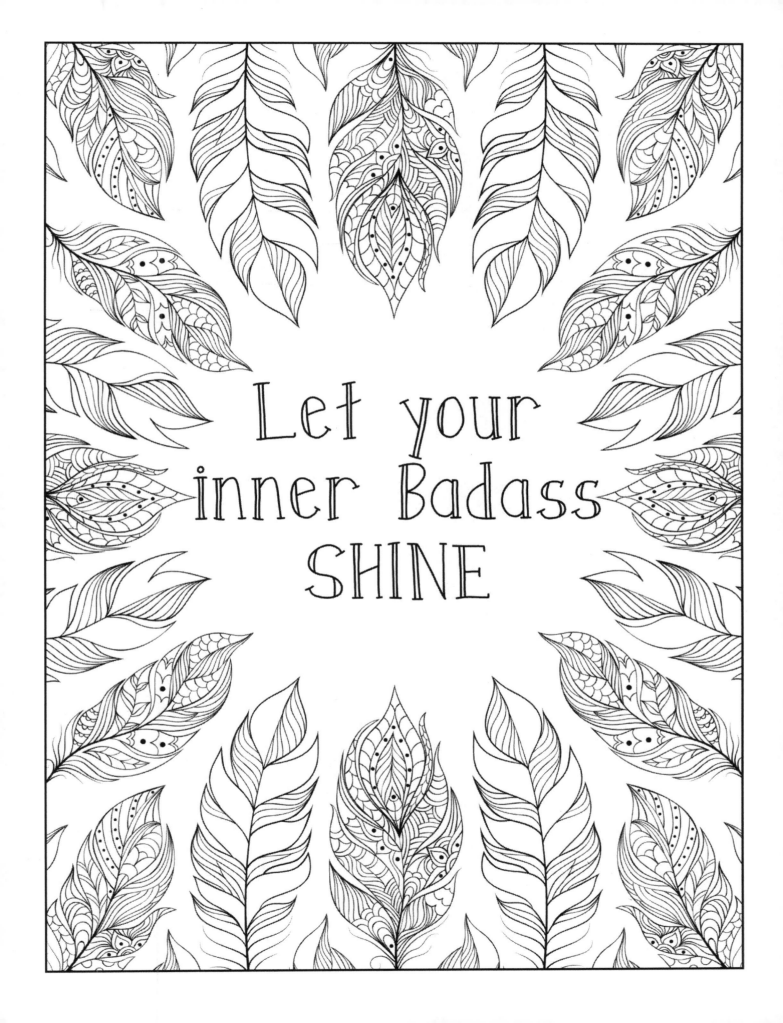

WE

STAND

TOGETHER

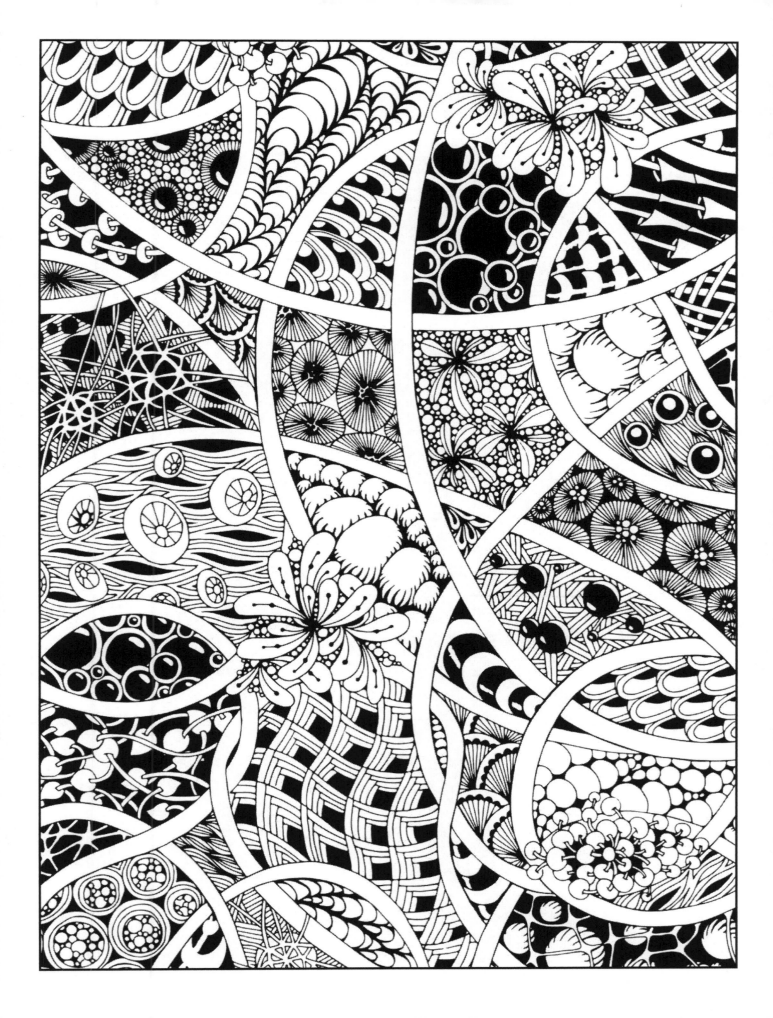

Truth *fucking* Matters

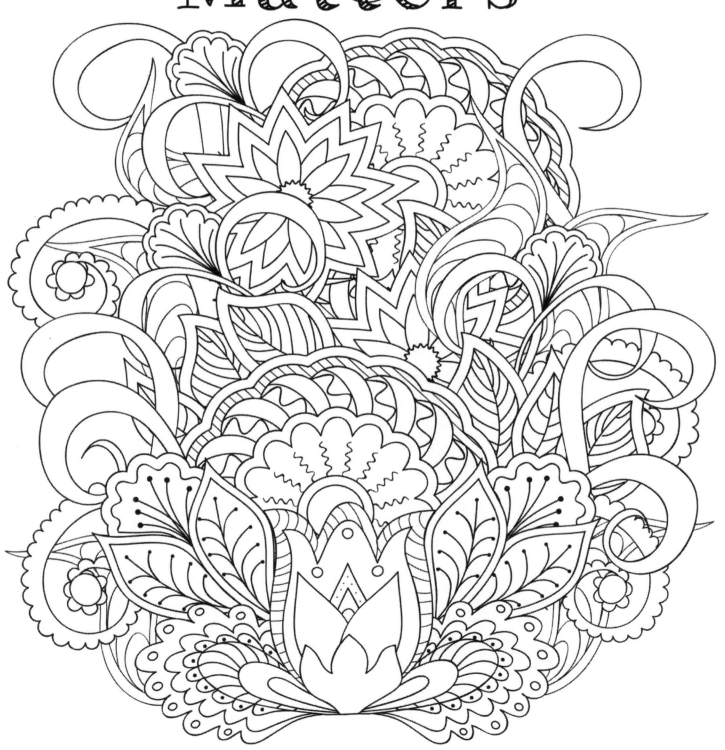

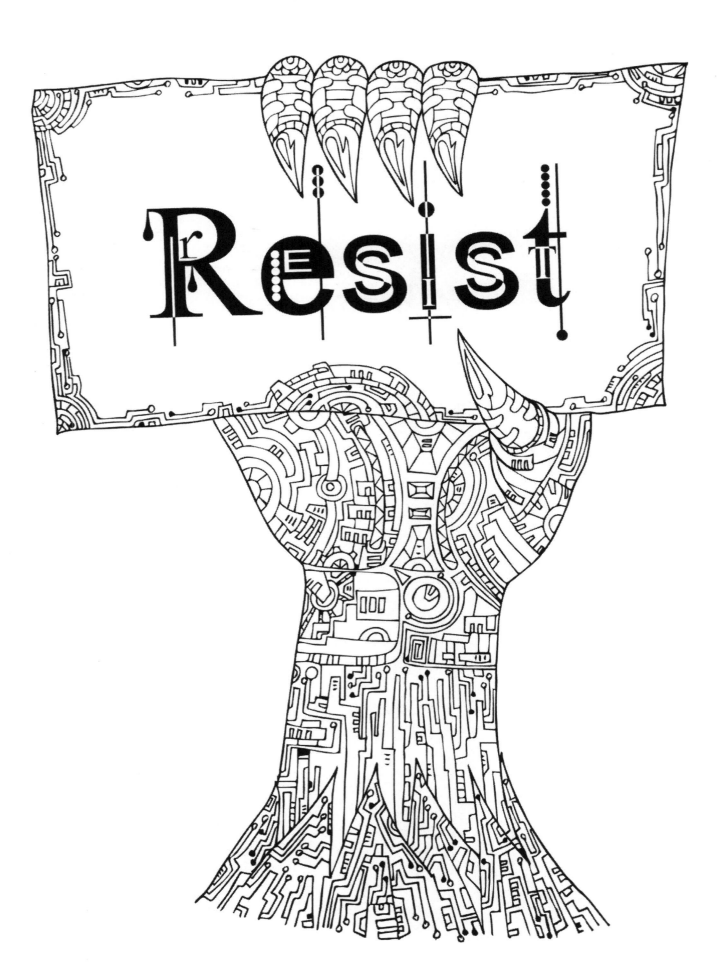

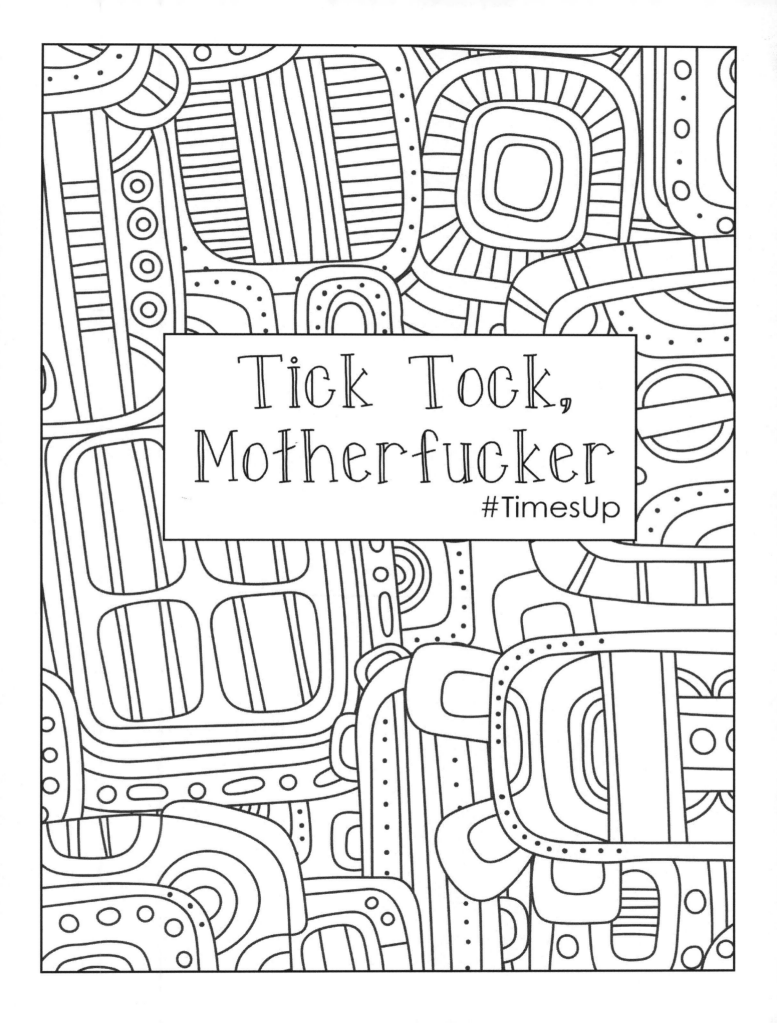

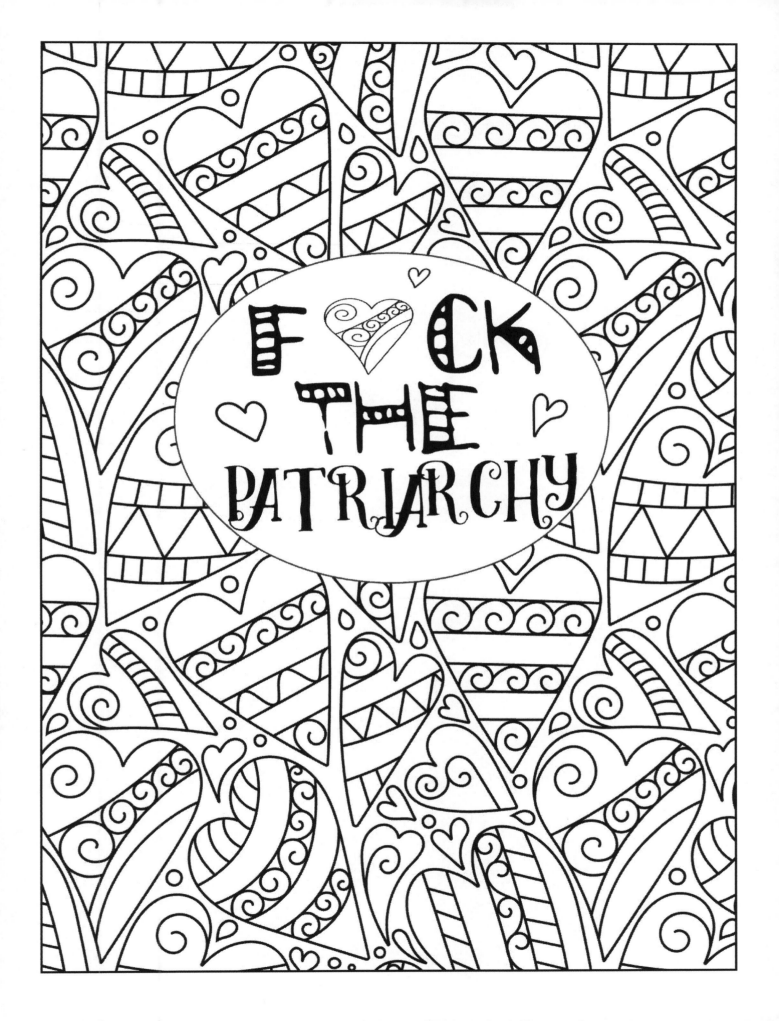

Thank You!

I truly hope you found this coloring book both relaxing and empowering. If you enjoyed it, please help others know whether they'd like it by posting a review wherever you purchased it. And please don't be a stranger! Visit me on Facebook at www.facebook.com/jmeyersbooks or drop me a line at jen@jmeyersbooks.com. I'm also on Twitter and Instagram as @jmeyersbooks.

Hope to meet you soon!
JEN

JEN MEYERS grew up in Vermont, spent three years in Germany when she was a kid, and now lives in central New York. When she's not reading, writing, or designing coloring books, she's chasing after her four kids, playing outside, relishing the few quiet moments she gets with her husband, and forgetting to make dinner.

Besides designing totally inappropriate (and totally appropriate) self-affirming adult coloring books, she also writes contemporary romance and young adult fantasy. She is the author of the (completely appropriate) *Intangible* series, the (perfectly inappropriate) *Happily Ever After* series and *Anywhere*, and co-author of the (totally inappropriate) *Untamed* series. For more information about Jen and her work, visit her website www.jmeyersbooks.com.

Made in the USA
San Bernardino, CA
27 May 2020